BLACK AMERICA SERIES
GREENSBORO
NORTH CAROLINA

REMEMBERING A COMPANION. Greensboro Four member Jibreel Khazan (Ezell Blair Jr.) kneels at the grave site of David Richmond. The two were Greensboro natives of the four A&T students that initiated the sit-in movement on February 1, 1960.

BLACK AMERICA SERIES

GREENSBORO
NORTH CAROLINA

Otis L. Hairston Jr.

ARCADIA

Copyright © 2003 by Otis L. Hairston Jr.
ISBN 0-7385-1525-6

First printed 2003
Reprinted 2003

PPublished by Arcadia Publishing
an imprint of Tempus Publishing Inc.
Charleston SC, Chicago, Portsmouth NH, San Francisco

Printed in Great Britain

Library of Congress Catalog Card Number: 2003102694

For all general information contact Arcadia Publishing at:
Telephone 843-853-2070
Fax 843-853-0044
E-mail sales@arcadiapublishing.com
For customer service and orders:
Toll-Free 1-888-313-2665

Visit us on the internet at http://www.arcadiapublishing.com

WARNERSVILLE BUSINESS AREA. The Warnersville business area, shown above, was removed due to urban renewal.

CONTENTS

Acknowledgments		6
Introduction		7
1.	Personalities: The African-American Persona	9
2.	Education: We Build Schools	31
3.	Religious Life and Churches: The Center of Our Joy	49
4.	Business in the Community: The Black Purse and Its Power	59
5.	Civil Rights: We've Been to the Mountain Top	71
6.	Sports: Athletic Prowess	81
7.	Life in the Communities: Distinguished Neighborhoods	93
8.	Social Life: Clubs and Festivities	113

Acknowledgments

Since conceiving the idea of this publication, many persons have shared their time, personal photographs, memories of the past, historical documents, newspaper articles, and many mementos. I am eternally grateful to all, including Betty Williams, Joe Williams, Joyce Johnson, Col. Larry Burnett, Julia Richmond, Rosa Yourse, Yvonne Johnson, Lucille Piggott, Carl Foster, Cameron Falkener, Richard Bowling, Shirley Frye, Mary Ann Scarlette, George Bishop, McArthur Davis, Jerrye Mooring, Ellease Colston, Wanda Davis, Tracey Burns, Cheryl Gould, Melvin Henderson, Peggy Horton, Roy "Spaceman" Thompson, Vandalia McAdoo, Ruth Totten, Jean Lanier-Rudd, Yolanda Leacraft, Helen Shoffner, Sadie Johnson, Nannie Dick, Zepplyn Humprey, Amos Faucette, Lynette Parks, Margaret Gill, Cirt Gill Jr., Eliza Burnett, Dianne Bellamy Small, Florine Stafford, Cal Irvin, David Morehead, Bill Howard, Arthur Crews, Arlene Yancey, Tina Hargett, Joe Daniels, Alma Adams, Mrs. W.A. Goldsborough, Thomas Scott Sr., Murphy Street,, Harold Cotton, George Evans, Linda Brown, Stu Ahrens, Laverne Harris, Jonathan McKee, Ray Flowers, Gerald White, Tony Quick, William "Bill" Peeler, and Pat Stewart.

 Steve Catlett, archivist at the Greensboro Historical Museum, provided images from the collections at the museum and we certainly appreciate the use of these historical photos. Lewis Brandon, who has documented much of the history of the African American community over the past several decades with photographic images and documents, was an invaluable resource with photographs and information about events. I appreciate and am proud to use his historical images in this book. Ben Poole, a native of Greensboro and a photographer for over five decades, has captured many images documenting African-American life in our community in addition to the many stories he shared of growing up in this community. I appreciate his willingness to share his historical images. I appreciate the use of Jack Moebes' images along with those of the *News and Record*.

 Martha Donnell, Harold Cotton, and John Harris have provided valuable historical information. Many images that were shared by those in the community were interpreted and the historical significance shared by them for use in this book. For Claudette Burroughs White's assistance in researching, providing photographic images, and helping to facilitate the overall completion of the book, along with her encouragement, I am eternally grateful. Gwenella Lambert Quick, who provided much technical assistance and also communication in securing images and information for this book, deserves a special appreciation. Maxine Bateman and Shirley McFarland are due special thanks for their work. And it is a must that I say thank you to Laura New, my editor from Arcadia, whom I have met only by phone and e-mail. Thank you for your valuable assistance, advice, and most of all, patience. All of the contributions of those mentioned were invaluable in completing this book.

 As a photographer I realize the value of a photographic image. Every time a shutter clicks it captures a moment in history. Much of the history of this community has been preserved with the images you will view. Again I say "THANK YOU" for the team effort of those above, whose efforts have helped capture a broad range of experiences with photographic images of the African-American community over many decades past.

INTRODUCTION

On July 18, 2000 my life forever changed with the death of my father, my hero. He was a man whom I had admired, respected, and loved, but I never fully realized the greatness of the life he lived and the impact his life had on this community—Greensboro, North Carolina. When I began to sort through the many historical documents, photographs, newspaper articles, and papers he left behind, I realized the legacy that remained. I envisioned a story that should be told, not just about the life of Otis L. Hairston Sr., but the African-American community—its beginnings, its struggles, its growth, its challenges, its personality, and its successes. With photography being my chosen profession, what better way for me to honor his memory than to produce through photographic images a book to capture the essence of the African-American community that he loved so dearly.

My grandfather, J.T. Hairston, was called to Greensboro in 1907 to pastor Shiloh Baptist Church in the Warnersville Community. He lived in the church parsonage for 53 years during his pastorate, only a block from the primary business district on Ashe Street. The memories of this grandiose house are still vivid, and yet I am reminded of it becoming a victim of redevelopment in the Warnersville Community in the 1960s. This community had produced many outstanding leaders in the city, including David Dallas Jones, first president of Bennett College.

Although my family has shared stories of life in Greensboro's African-American community from the early 1900s on, and I myself experienced events here in my home city, I realized it would take a great deal of further documentation and photographic images to produce the book I had in mind For example, although I spent much time in the Warnersville Community as a child, I had not realized until recently that it was the first organized African-American community in Greensboro.

Many other communities evolved after Warnersville, including the Lincoln Grove Community, originally called "Big Road." The McAdoos and several families settled in East Greensboro, which was very much a rural area for farming. In the 1950s the Paradise Drive Inn was a gathering place in the community because of segregation and a lack of places to go. Partly because of the deterioration of the Paradise and the attraction of drugs, the area became known as the "Grove" in the 1960s. Before closing in the 1970s the Paradise became known for its Fat Back sandwiches.

Goshen, Red Hill, Mount Tabor, Red Hill, Bass Chapel, Collins Grove, Florence, Jonesboro, Rena Bullock, Mount Zion, East White Oak, White Oak Grove, and others developed into communities for African Americans. Most of these were rural communities. I remember while a student at the segregated Dudley High School in the 1960s that many of my classmates were bused from these communities to attend the only high school in the city for African Americans. Despite this, there was a sense of "one community" and a sense of family among students, teachers, and parents. The school instilled a sense of pride in the community. Other nearby segregated schools such as William Penn in High Point, Atkins in Winston-Salem, Jordan Sellars in Burlington, Hillside in Durham, and Second Ward in Charlotte formed rivalries that instilled a sense of school spirit that ended with public school integration. Dudley continues to be a rallying point for African Americans. It has been listed in the National Historic Records as one of the only original segregated high schools left in the state.

As Bennett College, Lutheran College, and A&T College developed into strong educational institutions in east Greensboro, East Market Street became the focal point of African-American activity. Many businesses located on East Market Street included tailor shops, restaurants, cleaners, barber and beauty shops, service stations, funeral homes, grocery stores, and photography studios—everything but a bank. Many professionals located their offices on Market Street, including Drs. Evans, Miller, Sebastian, Davis, Barnes, and Steward. Many churches were also located on and around Market Street.

It was said by many middle-class African Americans that redevelopment was a blessing for Greensboro. But in hindsight it proved to be a fiasco for the vitality and intensity of East Market Street and its black businesses. Market Street, Gorrell Street, and Ashe Street businesses were destroyed by urban renewal and these neighborhoods have never been the same. It was said that the city's neglect in terms of providing sanitation, building code enforcement, and infrastructure improvements led to the severe deterioration of these neighborhoods during the postwar periods.

Civil Rights became a focal point for Greensboro in the 1950s and 1960s. The first public schools to be integrated in North Carolina were in Greensboro. The national Sit-In Movement was birthed at A&T College and the Woolworth lunch counter. The fight for integration of public accommodations was led by local ministers and community leaders. Jesse Jackson led A&T students and the Bennett College Belles also actively participated. The struggle for these rights in Greensboro proved to be non-violent compared to other movements in the Deep South.

This book is intended as a tribute to my father, Otis L. Hairston Sr., for the many years he devoted his life to the citizens of Greensboro, but also I find it important to salute and pay tribute to the leaders of this community, past and present, who have made a difference for African Americans in Greensboro, North Carolina.

I dedicate this book to my parents, pictured above, Otis and Anna Hairston Sr.

One
PERSONALITIES
THE AFRICAN-AMERICAN PERSONA

JUSTICE HENRY E. FRYE. As attorney, prosecutor, businessman, legislator, educator, and Supreme Court justice, Henry E. Frye has played a major role in Greensboro and North Carolina history. He was the first African American to be appointed Assistant United States Attorney in North Carolina in 1963, and he was the first African American elected to the North Carolina General Assembly since 1899. Frye served 12 years in the State House and two years in the Senate. An economic pioneer, Frye organized Greensboro National Bank, the city's first African-American bank, and served as president from its opening in 1971 until 1981. Another first was his appointment to the North Carolina Supreme Court in 1983 as Associate Supreme Court Justice, a first for an African American. He later was appointed Chief Justice in 1999. Pictured above in 1972 is the Frye family with Delores Tucker (right), Secretary of State for Pennsylvania, at a Frye campaign event.

DR. WILLIAM M. HAMPTON. Dr. William M. Hampton came to Greensboro in 1939 where he began his successful career as a physician. In 1941, he succeeded Dr. C. Stewart by taking over his practice in the Warnersville community. In 1951 Dr. Hampton became the first African American to be elected to the Greensboro city council, and was re-elected in 1953 with the highest number of votes polled. Due to his unique philosophy of serving the entire population of the city, Dr. Hampton was named to the school board in 1955, a position he held at the time of his death in 1960.

DR. WILLA B. PLAYER. Dr. Willa B. Player was the first woman to serve as president of Bennett College. She served as the 10th president, and during her administration Bennett was admitted to membership in the Southern Association of Colleges and Universities, one of the first African-American four-year colleges admitted to membership.

DR. GEORGE EVANS. After obtaining his medical degree, Dr. Evans came to Greensboro in 1935 to begin practicing medicine. He served on the staff of L. Richardson Hospital in addition to his medical practice. Dr. Evans served as chairman of the mayor's Human Relations Committee during the Civil Rights Movement in the 1960s. He also served on the Greensboro School Board for 10 years.

ATTORNEY HERBERT PARKS. "Herb rarely lost a jury trial because his oratory as a minister was very influential to juries," says a fellow lawyer. Herb Parks was a practicing attorney in Greensboro from the 1930s until his death in 1972. He never attended Law School, but received his license after studying in the law firms of Henderson and Frazier. He was admitted to the state bar in 1937. He was also a former law partner with Judge Elreta Alexander.

JAM-A-DITTY. Cirt Gill, pictured above in the studio, became the first African-American disc jockey in North Carolina in 1949. He was hired by WGBG, owned by Ralph Lambert. He played the popular music of that time, whether it was R&B, pop, blues, country and western, or jazz. His request line was popular with his listeners.

LOUIS ARMSTRONG. Upon hearing Armstrong was performing in the city, Gill requested and was granted an interview for the station.

J. KENNETH LEE. In 1952 Lee was one of the first two African-American graduates of the University of North Carolina Law School. He had been a plaintiff in the landmark United States Supreme Court case which opened the doors of the University of North Carolina at Chapel Hill to African Americans after 154 years of segregation. Upon graduation Lee practiced law in Greensboro for several years when he decided to build a home. With $35,000 cash in hand, he went to a local financial institution to seek a loan of $20,000. He was told "we do not make loans to Negroes for more than $13,000." Thus he saw a need for a financial institution for African Americans. In 1955, he spearheaded the idea to organize American Federal Savings and Loan.

DR. KATIE G. DORSETT. Dr. Dorsett's accomplishments have shown that community involvement is equal to academic achievement. "My public service role is an extension of my professional career as a teacher." After a substantial tenure at North Carolina A&T State University she was led to politics. She served on the Greensboro City Council and the Guilford County Board of Commissioners until she resigned in 1993 to serve as North Carolina Secretary of Administration in the cabinet of Gov. Jim Hunt. She was elected in 2002 to serve in the North Carolina Senate.

EVA HAMLIN MILLER. It has been said that "Eva Miller dedicated her life's work to the cause of raising the visibility of African American Artists in America." She became the first art instructor at Bennett College in 1937. She served as associate professor of art at North Carolina A&T State University and founded and owned the Z Gallery. Miller designed the stained-glass windows at Bennett College, Saint James Presbyterian Church, Saint Matthews Methodist Church, and Shiloh Baptist Church. One of the highlights of her career included an invitation by President and Mrs. Carter to the White House for her recognition as a major African-American artist. She is founder of the African American Atelier.

LILLIAN WELLS SNIPES. Snipes and Beautyrama are synonymous with beauty culture on the national, state, and local levels. She has been a strong and positive influence in the cosmetology field in Greensboro and North Carolina. For 22 years she served as president of the North Carolina State Beauticians and Cosmetologists. She was an advocate for education and strongly believed "one can never learn to much about their chosen profession." In 1999 she was inducted into the National Beauty Culturist League Hall of Fame.

JUDGE ELRETA ALEXANDER-RALSTON. In 1968, Judge Alexander-Ralston became the first African-American female judge in the country by appointment. Her lists of firsts include the first African-American woman accepted by the Columbia University School of Law, the first African-American woman to practice law in North Carolina, and the first African-American woman elected judge. She served on the bench from 1968 to 1981, and is credited with many daring changes in the court system.

DR. GEORGE SIMKINS. A Greensboro dentist and Civil Rights activist, Dr. George Simkins was president of the local NAACP Chapter from 1959 to 1984. He was involved in public and legal action to integrate golf courses, public libraries, municipal tennis courts, Moses Cone, and Wesley Long Hospitals. He was among the filers of a federal lawsuit regarding the need to integrate the Greensboro city schools. For years he led voter registration drives and a political action committee.

ZOE BARBEE. Zoe Barbee became the first African American elected to the Guilford County Board of Commissioners in 1974. She was killed in 1974, soon after her election, in a tragic automobile accident. Bert Hall was named to replace her. Zoe was a professor at A&T State University and a multi-talented woman. Here she poses with A.H. Peeler

GREENSBORO POSTMASTER. Enola Mixon was named postmaster in 1993. In the Greensboro area she supervises over 800 employees. She was active in the Civil Rights Movement in the 1960s, serving as a member and secretary of the Greensboro Citizens Association.

WILLIAM "BILL" MARTIN. Bill was first elected to the North Carolina Senate in 1982. He was re-elected for 10 consecutive terms through 2001–2002. In 2002 he did not run for re-election after his unsuccessful run for Congress in the newly formed 13th Congressional District. During his lengthy service in the Senate he served as chair of the North Carolina Legislative Black Caucus in addition to many influential Senate committees.

TELEVISION ANCHOR. Sandra Hughes began her career as a general assignment reporter at WFMY-TV in 1972. She tumbled into this reporter's job because an African American face on the television screen was becoming socially correct. But, "some people let me know they didn't want me here in some ways that were pretty threatening to me and to my family," she says. She was the first African-American woman to host her own talk show, *Sandra and Friends*, in the state. She currently co-anchors the 5, 6, and 11 p.m. newscasts on WFMY News 2 Monday through Friday.

Dr. Linda B. Brown. Despite being a published writer and novelist, Dr. Linda Brown perceives her role as a teacher as her greatest contribution. Her teaching career spans more than three decades. She enjoys teaching literature to young people and developing her own creative writings. Her publications include *Crossing Over Jordan*, *Rainbow 'Roun Mah Shoulder*, and *The Edge of Our World*. Dr. Brown is an advocate of social change and conducts workshops on racial awareness.

Yvonne Johnson. Elected mayor pro-tempore of the City of Greensboro in 2001, Yvonne is the first African-American woman to hold this position. She served several terms on the City Council before being voted unanimously to this position. Also, she is executive director of One Step Further, Inc., a sentencing alternative and a mediation center. She is a mediation expert and sought-after facilitator for racism and diversity workshops.

DAVID MOREHEAD. Helping other people has been David Morehead's vocation and avocation. One of the highlights of his life was the day the Hayes-Taylor YMCA was completed. Ceasar Cone said he would contribute $65,000 for a YMCA if Greensboro's African-American community would raise $5,000 to buy property for the Y. Hayes-Taylor YMCA was dedicated on December 30, 1939. Morehead was so enthusiastic about the new Y that he sold more memberships than anyone else. In 1943 he was employed as youth director, and four years later he became Executive Director. He retired in 1971 after helping many young people along the way. He served as an A&T trustee for 21 years, longer than any other person in the university's history. He was responsible for naming many of the buildings on the campus. He was the first African American to serve on the Greensboro Coliseum Commission.

WALTER T. JOHNSON JR. A distinguished native of Greensboro, he has been active locally and statewide as chairman of the Greensboro School Board and chairman of the North Carolina Parole Commission. A graduate of the Duke University Law School, he has practiced law in the city since the late 1960s. In addition he has served on the Human Relations Commission, the Greensboro Zoning Commission, and as chairman of the North Carolina Inmate Grievance Commission.

ERVIN BRISBON. Ervin Brisbon was a children's advocate and Civil Rights advocate. He agitated people and systems, but at his death he was mourned and applauded by many for his restless spirit to challenge injustice wherever he found it. He stood firm on issues of equal education and treatment of youth.

DR. ALMA ADAMS. Dr. Adams said, "Being an educator, being an artist helps me to be a good public servant." Dr. Adams combines all in serving as chairperson of Visual Arts and Humane Studies at Bennett College and as co-founder and vice president of the board at the African-American Atelier. She is also a member of the North Carolina House of Representatives. She chairs the Guilford Delegation at the North Carolina General Assembly and previously served as a member of the Greensboro School Board and the Greensboro City Council. Her mark of distinction is her collection of hats.

CLAUDETTE BURROUGHS-WHITE. Claudette says her professional and community service experiences have been useful in helping her to appreciate all people. Being one of the first African Americans to integrate the University of North Carolina at Greensboro (formerly Women's College), her professional and community involvement has been extensive. She has served the community on almost every board and commission having to do with children and youth. Since 199s4 she has served on the Greensboro City Council. She has served as local president as well as national vice-president of the National Black Child Development Institute, and has initiated a number of programs in Greensboro including the Black Quiz Bowl, the Black Child Choir, and the Back-To-School Extravaganza.

DR. ALFREDA WEBB. On January 19, 1972, Dr. Webb became the first African-American woman to serve in the North Carolina General Assembly. Her appointment was made by Gov. Bob Scott. She served as a professor in the Animal Science Department at A&T State University, being one of the first African-American female veterinarians in the country.

THURMAN GANT. Gant was dubbed the "Godfather" of the residents of the East White Oak Community. The community was founded by the Cone family for African Americans working at the Cone Mill Plants. The Cones built the community during the early 1900s. Gant worked for Cone Mills for 32 years and lived in East White Oak for over 75 years.

"THE PEOPLE'S MAN." Jimmie I. Barber was affectionately known as the "People's Man." He served as director of housing at A&T State University. He served on the Greensboro City Council and was very active at his church, the United Institutional Baptist Church. Barber Park was named in his honor because of his service to the community.

ATTORNEY JOE WILLIAMS. Joe Williams has served as Assistant District Attorney in Guilford County and as a district court judge. He presently is an outstanding trial attorney in the city. Joe is the first African American to serve as president of the Greensboro Bar Association.

AGGIE HERO. Ron McNair graduated from A&T in 1971 with a major in physics. Upon graduation he pursued a graduate degree from MIT and received his doctorate. He was then selected as one of the first African-American astronauts. Ron and his fellow *Challenger* astronauts were killed in the shuttle explosion in 1986.

STUDENT SPACE SHUTTLE PROGRAM. Ron McNair had begun a Student Space Shuttle Program in 1980 at A&T soon after his selection to the astronaut program. Above, members of the program along with their advisor, Dr. Stu Ahrens, watch television coverage of the tragedy.

CITY HONORS MCNAIR. After his first shuttle mission in 1984 Ron returned to his alma mater to be celebrated for his achievements. Above, Ron presents Mayor John Forbis with a souvenir from the shuttle mission.

MCNAIR HALL. A&T named its newly constructed Engineering Building in honor of McNair. Above, Cheryl McNair, widow of Ron McNair, and Chancellor Edward Fort view the unveiled bust located in front of McNair Hall. The College of Engineering graduates more African-American engineers than any other university in the country.

SARAH HERBIN. Education was a career Sarah Herbin chose until called by former Gov. Terry Sanford to serve in his administration. Her job was to recruit African Americans for non-traditional jobs in state government. When this appointment ended, she refocused her attention on youth. She founded the national and local Black Child Development Institute to serve young people.

EARL JONES. Jones served for 18 years on the Greensboro City Council and is presently a newly elected member of the North Carolina General Assembly. As a council member he was an advocate for police foot patrols in public housing areas, and advocated city bond referendums for transit, housing, libraries, and recreation. He is a co-founder of the Sit-In Movement, Inc. Jones presently is also the owner and publisher of the *Greensboro Times*, a bi-weekly newspaper.

MELVIN "SKIP" ALSTON. An entrepreneur, politician, and Civil Rights activist, Skip was elected to the Guilford County Board of Commissioners in November 1992. He was elected chairman of the board in 1993. He serves as state president of the North Carolina State Conference of NAACP Branches. He is also a member of the National NAACP board of directors. Skip is co-founder of Sit-In Movement, Inc., a nonprofit organization founded for the purpose of renovating the historic Woolworth Building (home of the sit-ins) in downtown Greensboro into an International Civil Rights Center and Museum.

Dr. Michael A. King. As student body president of James B. Dudley High School, Michael King showed leadership that was destined for greatness. He became the youngest elected member of the Greensboro School Board. He was called into the ministry in 1978 and established Garden of Prayer Baptist Church in 1979. Ten years later, desirous to meet the ever-increasing need for affordable housing in Greensboro and Guilford County, he founded Project Homestead, a nonprofit housing and community development initiative. It has invested in housing for more than 800 families. Pictured above he presents roses to Maya Angelou before she cuts the ribbon to Project Homestead's first minority-owned Krispy Kreme in the country. Also shown is Bennett College president Dr. Johnnetta Cole.

Two
EDUCATION
WE BUILD SCHOOLS

Goshen Elementary-High School

GOSHEN ELEMENTARY SCHOOL. Students from the Red Hill and Mt. Tabor communities commuted to Goshen to make up the student body of the Goshen Elementary School. It was located on the site of the present Goshen United Methodist Church. The school included first through ninth grade; upon completing ninth grade students were bused to Dudley High School, the only high school in the city for African Americans. F.B. Morris was principal of the school. He was also one of the organizers of the now famous baseball leagues in the Goshen Community. Because of the lack of space, the school was relocated to the Pleasant Garden community and renamed Rena Bullock School. Rena Bullock was one of the first teachers at the Goshen School and is pictured on the far left.

PALMER MEMORIAL INSTITUTE. In 1902, after vigorously raising money in New England, Charlotte Hawkins Brown founded the Palmer Memorial Institute, a day and boarding school. She established the school in a converted blacksmith's shop and named it in honor of Alice Freeman Palmer, her mentor and benefactor. In its earlier years, Palmer's curriculum emphasized agriculture and industrial education for rural living. Brown expanded the school to more than 350 acres, including a sizeable farm. As years passed, the school's academic importance and its emphasis on cultural education increased. During her 50-year presidency more than 1,000 students graduated. Dr. Brown died in 1961. Ten years and three administrations later Palmer closed its doors to students. Dr. Brown poses with a sculpture of Alice Freeman Palmer. Palmer Memorial Institute is now a North Carolina Historic Site. (Courtesy of Alex Rivera.)

MODERN DANCE GROUP. Dancers at Palmer perform as part of its cultural arts program. Ruth Totten, teacher and guidance counselor, organized the group. (Courtesy of Griffith Davis Collection, Duke University.)

STUDENT ASSEMBLY. Dr. Brown addresses students at an assembly in the auditorium. Note male and female students sat separately. (Courtesy of Griffith Davis Collection, Duke University.)

PRICE SCHOOL. This is an early class from the J.C. Price School in the late 1920s or early 1930s. It was located in the Warnersville community. (Courtesy of Greensboro Historical Museum.)

A.H. PEELER. Abraham H. Peeler was a lifetime educator and principal of the former Price Elementary and Junior High School. He was an educational consultant for the African-American community. He retired from Price following 43 years in education. An elementary school and community center in the city are named in his honor.

DUDLEY HIGH FACULTY. This undated photograph shows the faculty of Dudley High School posing with the principal, Dr. John Tarpley (front center).

DR. JOHN TARPLEY. John Tarpley devoted over 40 years to educating the youth in Greensboro. He was known as a stern disciplinarian. He served as principal of Washington Street School before coming to James B. Dudley High School.

BENNETT HIGH SCHOOL. Bennett College graduated its last high school class for females in 1932. Six years earlier the last co-ed high school class graduated in 1926.

UNDEFEATED LASSIES. Bennett College had the only undefeated basketball college teams in the state in 1934–1935. Dr. William "Bill" Trent coached these undefeated teams.

BENNETT MAY DAY. Pictured is the annual May Day Celebration in 1955. Geneva Averett (center) is shown performing with some of the modern dance students. Activities included the crowning of a May Day Queen, wrapping the May pole, drama, dance, and other entertainment.

SHOPPING BELLES. Two Bennett Belles shop downtown during the 1950s. The Belles were required to wear hats and gloves when visiting the downtown area. Students were also required to travel off-campus with two or more students accompanying them. (Courtesy of Greensboro Historical Museum.)

SANFORD VISIT. Former governor and senator Terry Sanford visited the campus to speak at a college convocation in the 1980s. He poses with Bennett Belles after the program.

SCOTT INAUGURATION. Dr. Issac Miller, the college's 11th president, congratulates Dr. Gloria Scott at her inauguration. Looking on is Dr. Willa Player, the 10th president of the college.

BARBARA BUSH VISIT. Dr William "Bill" Trent was instrumental in getting First Lady Barbara Bush to visit the campus as a commencement speaker. Trent first came to Bennett in 1934 and left to become director of the United Negro College Fund. He returned to Bennett in 1976 as a consultant to President Miller.

"SISTER PRESIDENT." Dr. Johnnetta Cole is introduced to the Bennett College Family and Greensboro Community as the 14th President of the College.

CATHOLIC SCHOOL. Saint Marys Catholic School opened in the late 1940s for African-American students. It was located on Gorrell Street. Students knew the school as Our Lady of the Miraculous Medal School. (Courtesy of Greensboro Historical Museum.)

FLORENCE SCHOOL. Students pose with teacher Mr. Virgil Stroud, located in the lower center of picture. Upon graduating from the school, students had a choice of attending Dudley High School or William Penn High School in High Point.

WASHINGTON STREET SCHOOL. Students at the school pose for a class picture in the early 1930s.

LINCOLN STREET SCHOOL. These students are in a Junior Red Cross Class in the 1950s. Lincoln was opened in 1949. (Courtesy of Greensboro Historical Museum.)

AGGIE GRADUATION. The A&T College band leads the graduation processional through the campus. A&T was founded in 1891. (Courtesy of Greensboro Historical Museum.)

FACULTY AND STUDENTS PROCESSIONAL. A graduation procession follows the band through the campus. The procession is following unpaved Nocho Street showing Murphy Hall in the background. The university now graduates over 2,000 students annually. (Courtesy of Greensboro Historical Museum.)

CALDWELL SCHOOL FACULTY. After Asheboro Street (presently Martin Luther King Drive) became a predominately African-American community in the late 1950s, Caldwell School followed and became predominately African American. The new faculty is pictured below with the Principal Goldsborough seated center. After the closing of the school it was preserved as the Nettie Coad Apartments.

WASHINGTON STREET SCHOOL FACULTY. Pictured above is the 1950s faculty of Washington Street School. It was one of the first elementary schools to open for African Americans in the city. John Leary, seated on far right, was principal.

A&T PRESIDENTS AND CHANCELLORS. The 1991 Centennial Celebration at A&T found the former leaders of the university posing for a group photograph. Pictured above from left to right are Chancellor Edward Fort, Dr. Warmouth Gibbs, Dr. Samuel Proctor, Dr. Lewis Dowdy, and in rear is Dr. Cleon Thompson. Dr. James Renick is the current chancellor.

TALENTED TEACHERS. A group of public school teachers formed a basketball team that competed against the women's teams at Bennett College and A&T College. Some of the teachers were former high school and college players but others joined the team just for "the fun of it."

DUDLEY DANCE RECITAL. The Dudley High School Dance Group performs its annual concert with a dance addressing current student issues.

GEORGENE DYE. A tradition was started at Dudley by Georgene Dye, a dedicated teacher and creative dance instructor. She also was in charge of the Majorettes and Pantherettes. Her teaching was not just confined to Dudley as she took her students out into the community to teach young girls creative dance and grace.

LUTHERAN COLLEGE. The Lutheran College opened in Greensboro as a four-year high school and two-year junior college and seminary in 1905. It was located east of the A&T College campus. The college enrolled 200 students from many areas of the country. Pictured above is the administration building, which housed the administrative offices, library, chapel, seminary, boys dormitory, and dining hall.

GRACE LUTHERAN CHURCH. This church was established in 1894 and chartered in 1897. The church is the oldest standing structure among the African-American churches in the city because of redevelopment. Above, the congregation celebrates a recent church anniversary.

GREENSBORO SCHOOL BOARD. This is the last official group photograph of the Greensboro School Board chaired by James "Jim" Davis prior to the merger with the Guilford County Schools. Other African-American board members are George Brooks, second from left, and Julius Fulmore, second from right.

VANCE CHAVIS. An outstanding educator in the Greensboro school system, Vance Chavis was a teacher at Dudley High School in the 1930s and became principal of Lincoln Junior High School. After his retirement he was elected to the Greensboro city council. Vance Chavis Library is named in his honor.

47

AGGIE GENERALS. A&T has produced many outstanding officers from its Army ROTC Department. Above are Five Army ROTC graduates who reached the rank of General. From left to right are Brig. Gen. Clara Adams-Ender, Brig. Gen. Vondere Deloatch, Maj. Gen. Charles Bussey, Maj. Gen. Reginald Clemmons, and Maj. Gen. Hawthorne Proctor.

Three
Religious Life and Churches
The Center of Our Joy

Trinity AME Zion Church. In 1891 AME Zion Bishop James J. Moore sent a Rev. Dr. William Goler to Greensboro to organize a church. Goler led 40 Zionites, who had come to Greensboro from Chatham County for better opportunities, to form what is known today as Trinity AME Zion Church. The first structure was located on the corner of Washington and Gilmer Streets. Membership grew to 600 during 1910–1960. With the largest seating capacity accessible to the black community it was often used for conventions by community organizations. Former pastors Rev. Cecil Bishop and Rev. Joseph Johnson have been elected Bishops in the AME Zion Church.

PROVIDENCE BAPTIST CHURCH. In 1866, a year after the Civil War, a band of worshippers organized Providence, Greensboro's first African-American Baptist church. In 1876 the first brick church for African Americans in the state was erected by Providence. During urban renewal in the 1960s the church was forced to move and was relocated to its present site on Tuscaloosa Street. Pictured above is the first brick structure built by the church.

DR. HOWARD A. CHUBBS. Dr. Chubbs was called to pastor Providence in 1966. He currently serves as the Senior African-American pastor in Greensboro.

REV. JUILIUS T. DOUGLAS. Reverend Douglas was the pastor of St. James Presbyterian, one of the two oldest African-American churches in the city, from 1946 to 1971. It was founded in 1867. Aside from a very active pastorate at St. James Presbyterian church for over 25 years, Reverend Douglas was deeply involved in Greensboro community affairs, including two unsuccessful campaigns for the Greensboro City Council. He served as president of the NAACP, as a member of the City Housing Commission, and during the Civil Rights Movement he served as chairman of the "The Buyers Resistance Movement."

EARLY SCOUTS. Reverend Weatherby, pastor of St. Matthews, organized the second African-American Boy Scout troop at St. Matthews Methodist Church in the early 1930s. The first troop was organized at Shiloh Baptist Church under the leadership of Rev. J.T. Hairston. Pictured on the left is A.H. Peeler, scoutmaster.

UNION CEMETERY. The cemetery was established by three churches in the 1800s, including St. Matthews Methodist Church, St. James Presbyterian Church, and Providence Baptist Church. The cemetery was saved and underwent extensive restoration in recent years, sponsored by the Greensboro Alumnae Chapter of Delta Sigma Theta Sorority and the City of Greensboro. It has been entered into the National Register of Historic Places.

NEW ZION. Members of New Zion Missionary Baptist Church stand on the steps of their new church after being relocated from the Warnersville area because of redevelopment. The church is located on Asheboro Street (Martin Luther King Drive). During the late 1950s and early 1960s the Asheboro Street neighborhood went through a conversion from being an all-white neighborhood to predominately African American. White churches fled the neighborhood and were purchased by African-American congregations. Rev. William Wright, former president of the Pulpit Forum, is the present pastor.

MINISTERIAL ALLIANCE. An organization of ministers was formed in the 1930s by Reverend Weatherby of St. Matthews Methodist Church and Rev. J.T. Hairston of Shiloh Baptist Church. Pictured above is the group of ministers in 1935.

REV. J.T. HAIRSTON. Reverend Hairston receives a presentation from Dr. O.L. Sherill of the General Baptist State Convention during the celebration of his 50th pastoral anniversary at Shiloh Baptist Church.

SHILOH BAPTIST CHURCH. The redevelopment of the Warnersville community created the opportunity for much newer construction at the expense of historic buildings. Pictured above is the groundbreaking for the new church with the historic building in the background. The people standing in the foreground is where the new church was built.

Rev. Prince Graves. Pastor of St. James Baptist Church for over 40 years, Reverend Graves instilled pride in the African-American community of Greensboro with many outreach programs sponsored by his church. His congregation sponsored housing for elderly and low-income citizens and a free breakfast program for school children. He also served on the Greensboro city council. A familiar quote of his was, "God never made any junk, that's why my momma and daddy named me Prince."

Rev. Charles and Rev. Lois Anderson. The Andersons are honored at an anniversary program honoring their service to United Institutional Baptist Church and the community. The Andersons served the church for almost 50 years. Institutional played an important role during the Civil Rights Movement in the 1960s.

MINISTERS' PROTEST. In April 1968, members of the Greensboro Citizens Emergency Committee—all ministers—urged a boycott of any retailer who failed to offer African-American employees a fair wage. (Courtesy of *News-Record*.)

REV. FRANK WILLIAMS. As a young minister Frank Williams was involved in the Civil Rights struggles of the 1960s. He was a man who strongly stood by his convictions. He was jailed for refusing to testify about confidential conversations with a church member. In 1967 his church purchased a parsonage for he and his family in an all-white neighborhood. He and his family were subjected to Ku Klux Klan protests and a cross was burned in his yard. He pastored Mt. Zion Baptist Church until founding New Jerusalem Cathedral.

PASTOR NANCY C. WILSON. A native of Greensboro, Nancy Wilson was reared in the church and began singing in the choir as early as age four. For over 20 years, she hosted and sang weekly on Gospel Expo, which was seen every Sunday morning on ABC, now FOX 8. Pastor Wilson was named one of Greensboro's 100 most influential women in 2000. Currently she pastors one of the most up and coming churches in Greensboro, New Beginnings Community Outreach Church.

BISHOP GEORGE W. BROOKS. After accepting the call to the ministry in 1974, he began his service as pastor of Mt. Zion Baptist Church in 1975 with a membership of 35. Today, under his leadership, the church has grown to a membership of over 5,000 with a staff of 87. He oversees Mt. Zion's 75 ministries, including a day care and after-school programs serving 270 youth. He has served the community as a member of the Greensboro Board of Education.

REV. OTIS HAIRSTON SR. Reverend Hairston can be described by those whose lives he touched as a caring, compassionate pastor, minister, leader, and friend. He pastored Shiloh Baptist Church for 34 years, developing ministries that reached the entire community, including housing and day care. He was involved in the Civil Rights Movement in the 1960s as a charter member of the Human Relations Commission. He served on the Greensboro School Board during the period of school integration. He was recently honored with the naming of a newly built middle school in his honor—the Otis L. Hairston Sr. Middle School. He is pictured above with former Gov. Jim Hunt, congratulating him after he received the NCCJ Brotherhood Award.

K-MART PROTEST. Members of the Pulpit Forum protest the low wages at K-Mart during the 1990s. The Pulpit Forum is an organization of African-American ministers in the city. Rev. William Wright led protesters as president of the Pulpit Forum.

Four
BUSINESS IN THE COMMUNITY
THE BLACK PURSE AND ITS POWER

D.W. MCADOO TRUCKING. In the late 1920s Mr. Walter McAdoo was the first African American in Greensboro to own a moving truck. Prior to this time he worked on what was then known as the "Dray Lines." These consisted of a horse- or mule-drawn carts. He serviced the African-American community, moving people from house to house as well as moving businesses from Greensboro, Reidsville, Asheboro, Burlington, and High Point. On the weekends he would put straight-back chairs on the back of the truck and transport people to church associations and homecomings, picnics, and hayrides.

WARNERSVILLE URBAN RENEWAL. Only three businesses survived redevelopment in the Warnersville community. Hargett Funeral Home ,which was established in 1922 at 712 South Street, moved t o East Market Street. Thomas Fairley and his wife Thresia started his nightclub and café, The Little Spot, in the late 1940s on Ashe Street. This Club attracted many noted R&B performers, including Ike and Tina Turner and Sam and Dave. Leaving the club after redevelopment, the Fairleys opened Tom's Take Home Restaurant on Asheboro Street. The other business that survived redevelopment was Smith Funeral Home, owned and operated by E.E. Smith, which moved to Asheboro Street. Pictured above is Smith Funeral Home, which was located on Ashe Street.

BUSY BEE CAFÉ. Mr. and Mrs. Myers were owners of the Busy Bee Café on East Market Street, which was open 24 hours a day. It was home cooking at its best. Hot biscuits were served all day, and everything was homemade, including pies and cakes.

WARNERSVILLE GROCERY. Walter and Georgia Marsh opened the first grocery in the Warnersville community. It was located on the corner of Ashe and Marsh Streets.

61

DANIEL TAXI. This taxi service opened in the early 1920s. It was located on the corner of Gilmer and Market Streets. It later became Daniel-Keck Taxi.

HALF MOON CAFÉ. An early popular eating spot on East Market Street located near A&T College was Half Moon Café. Hayes Taylor YMCA was built on the spot of the café in 1939. (Courtesy of C. Martin Collection, Greensboro Historical Museum.)

HARDY'S STUDIO. Leon Hardy opened one of the first photography studios on East Market Street. He was the photographer for many of the major events in the African-American community and was an outstanding portrait photographer. In addition to his studio operation he taught photography at A&T College and served as the college photographer.

ROYAL TAXI. Another of the taxi businesses that African Americans operated starting in the 1920s was Royal Taxi. Above, John Harris Sr. poses by his taxi.

MR. AND MRS. ALEXANDER FAUCETTE. Alexander Faucette was one of the greatest music promoters and supper club owners in Greensboro's history. He owned and operated the El Rocco Supper Club during the 1950s and 1960s. It was frequented by many in Greensboro and the surrounding areas. R&B and jazz entertainers who performed were Otis Redding, Jackie Wilson, Gladys Knight, James Brown, Red Foxx ,and Lionel Hampton. Thanks to his wife and others, the supper club was known for having the best fried chicken in Greensboro.

CARLOTTA SUPPER CLUB. Opened in 1961 by Minnard H. Peek, the supper club was one of two dinner clubs that offered nationally known rhythm and blues artists during the 1960s. Local organizations rented the club for social affairs. Sunday afternoon cocktail sips were popular with local musicians performing. Pictured above left to right are "Bunny" Segal, Donal Trapp, Vic Hudson, and "Foots" Harrison.

McRae Taxi. This taxi company was owned by the Tatums and was located next to the Grand Hotel on Market Street. Many of the entertainers who performed at the local clubs stayed at the Grand when in town.

The Carolina Peacemaker. John and Vickie Kilimanjaro (formerly Stevenson) formed the *Carolina Peacemaker* in 1967 as a voice of the black community. It has since been an important part of Greensboro history, particularly in the areas of economic development, Civil Rights, and human relations. Its investigative stories, opinion columns, editorial cartoons, and photography have been nationally recognized .

AMERICAN FEDERAL SAVINGS AND LOAN. This first-ever African-American owned and managed savings and loan institution in North Carolina was issued its charter in February 1959. The institution met the needs of home loans for the African-American community because of loan limits to African Americans from other lending institutions in the city. Pictured is the first building that housed the American Federal on East Market Street.

A.S. WEBB. A.S. Webb came to Greensboro as the managing officer of American Federal Savings and Loan and proved to be the right man for the job. He became a community leader, serving as the first chairman of the Human Relations Commission and chairman of the board of L. Richardson Hospital.

BOARD OF DIRECTORS. Pictured are the board of directors of American Federal Savings and Loan. From left to right are (seated) Arthur Totten, Julius Rankin, Kenneth Lee (board chairman), Arthur Lee, and E.E. Smith; (standing) Melvin Alexander, Waddell Hinnant, Robert J. Brown, B.J. Battle, Prince Graves, and A.S. Webb (managing officer).

CHEF EDDIE. Chef Eddie poses in his restaurant before being closed by Market Street redevelopment. He was best known for his soul food—chitterlings, fried chicken, collard greens, and yams. His restaurant was located next to "Boss Webster" and "Moms" Variety Store. They all served the students of A&T and Bennett College.

Redevelopment in the East Market Street and Washington Street areas changed the context of black life in Greensboro. Market Street had been the focal point of black life since the 1930s. Blacks went there to have a tooth pulled by Dr. Barnes; to get a hot meal at Farley's Grill; to catch a taxi from McRae's Taxi; to meet a sweetheart for a date at the Palace Theater; to eat a bologna and cheese from Boss Webster; or to attend worship at Providence Baptist Church. In total there

NAME	OLD ADDRESS
Varsity Inn	1500 E. Market St
Sanitary Barber Shop	1500 E. Market St
Crystal Tap Room	1625 E. Market St
Skylight Café	1422 E. Market St
Wynn Drug Store	814 Gorrell St
Peoples Auto Repair	108 S. Luther St
Wilkins Beauty Nook	1600 E. Market St
Bowman Chapel Church	113 Powell St
Shaw's Curb Market	1418 E. Market St
Kyle's Friendly Service	1711 E. Market St
King Drug Store	917 Gorrell St
Delux Beauty Shop	1222 E. Market St
Carolina Florist	1801 E. Market St
Reynolds Barber Shop	1500 E. Market St
Carolina Peacemaker	912 Gorrell St
Lyn's Quality Seafood	806 Gorrell St
King's Barbecue	914 Gorrell St
Shingle Barber Shop	506 Best St.
Hairston TV Repair	1308 E. Market St
Triangle News	1330 E. Market St
Reddick's Barber Shop	1328 E. Market St
Lou's Frank House	1324 E, Market St
Elite Clothing Company	1322 E. Market St
Carl's Famous Foods	1320 E. Market St
Hayes Beauty Shop	1326 E. Market St
J. Ball Billiards	1608 E. Market St
University Market	1511 E. Market St
Leach's Beauty Shop	969 E. Washington St
Community Grocery	924 Gorrell St
Ethel's Bake Shop	926 Gorrell St
Boston Café	918 Gorrell St
Chef Eddie's	103 Powell St
Gate City Seafood	1412 E. Market St
University Laundry	101 Powell Street

were over 70 businesses that were affected by redevelopment along the East Market Street corridor alone. The chart below will indicate the results redevelopment had on some of these businesses. It should reflect the almost impossible task of successfully relocating to an area away from the area it had served clients for generations past.

NEW ADDRESS RELOCATION	PAYMENT
Out of Business	5,318.08
Out of Business	2,824.00
Out of Business	5,500.00
Out of Business	5,310.90
Out of Business	2,500.00
Out of Business	2,500.00
Route 6, G'boro	2,500.00
337 Gorrell St.	613.00
1921 McConnell Rd	6,426.30
Out of Business	3,238.94
Out of Business	2,500.00
Out of Business	2,500.00
331 E. Market St.	6,093.00
Out of Business	5,212.36
530 Southeastern Bldg	2,995.00
Out of Business	3,555.52
2104 Phillips Ave	13,910.00
Out of Business	3,152.96
Out of Business	572.00
Out of Business	6,154.42
Out of Business	4,172.93
Out of Business	2,500.00
128 W. Sycamore St	2,500.00
2027 Asheboro St	9,932.00
713 E. Market St	3,213.28
Out of Business	1,251.60
Out of Business	5,500.00
Out of Business	4,589.00
Out of Business	4,233.00
Out of Business	2,771.86
Out of Business	4,842.17
Out of Business	3,600.00
2033 E. Market St.	4,206.43
Out of Business	2,500.00

GREENSBORO NATIONAL BANK. Shirley Frye, wife of Greensboro National Bank founder Henry Frye, makes a presentation to Patricia Holshouser, wife of Governor Holshouser, at the opening of Greensboro National Bank.

JAMES "SMITTY" SMITH. "My mission is to serve as a positive role model to African-American youth in the Greensboro community," says James Smith. This he has done as an entrepreneur, by currently owning and operating four McDonald's franchises in the Greensboro area. He has provided the business vehicle to employ community youth, emphasizing the proper work ethic needed to succeed in the business world. It is ironic that the first McDonald's that opened in North Carolina was segregated—and is now owned by Smith. He is pictured at the Summit Avenue McDonald's.

Five
CIVIL RIGHTS
WE'VE BEEN TO THE MOUNTAIN TOP

THE GREENSBORO FOUR. On February 1, 1960, four A&T College students walked to the downtown Woolworth's to challenge the store policy of "whites-only lunch counters." They sat down at the counters and were refused service. Their actions sparked a nationwide Civil Rights Movement. Picture above from left to right are Franklin McCain, Ezell Blair Jr., David Richmond, and Joseph McNeil. (Courtesy of Jack Moebes, *News-Record*.)

LUNCH COUNTER MANAGER. David Richmond hugs Ima Edwards, manager of the Woolworth lunch counter on February 1, 1960, when the students began their sit-in. The photograph was taken in 1990 at the 30th anniversary of the sit-ins.

THIRTIETH ANNIVERSARY. The 1990 anniversary celebration of the sit-in movement shows the four viewing a plaque presented in their honor. Pictured from left to right are Frank McCain, David Richmond, Jibreel Khazan (Ezell Blair Jr.), and Joseph McNeil.

MARTIN LUTHER KING. Martin Luther King was invited by the NAACP to speak in Greensboro in 1958. None of the churches, schools, or organizations in the city would provide a venue for him to speak. Dr Willa Player opened the doors of Bennett College to him saying, "This is a liberal arts college where freedom rings, so Martin Luther King can speak here." He spoke in Annie Merner Chapel and afterwards was interviewed by Bennett Students.

SCHOOLS DESEGREGATE. Five black students became the first black students in North Carolina history to desegregate a public school. They entered previously all-white Gillespie Park School. The next day a sixth student, Josephine Boyd, enrolled at all-white Greensboro Senior High School, now Grimsley. Seated from left to right are Harold Davis, Brenda Florence, Jimmy Florence, Russell Herring, and Elizah Herring. (Courtesy of *News-Record*.)

WE SHALL OVERCOME. During a 1980s celebration of the anniversary of the Greensboro Four and the sit-in movement, the head table leads the audience in the singing of "We Shall Overcome."

Coretta Scott King was the guest speaker. The banquet was a part of the February One Society's planned activities and was held at The Cosmos II.

NATIONAL NEWS. The national news media describes the events of November 3, 1979 at the anti-Klan rally in Greensboro.

PRESS CONFERENCE. The Greensboro Massacre Truth and Reconciliation Project seeks to tell the true story of what happened in Greensboro on November 3, 1979. The project is being chaired by former mayor Carolyn Allen and Z. Holler. Pictured from left to right are Claudette Burroughs-White, Z. Holler, Carolyn Allen, and Rev. Nelson Johnson, participant in the November 3rd "shoot out."

76

"SAVE OUR CHILDREN." This was the cry of citizens to the proposed cuts in social programs by the county commissioners in the late 1980s. The protests were led by the Pulpit Forum.

LEWIS E. BRANDON III. A Civil Rights activist who has devoted a lifetime to social justice, Brandon remained in Greensboro after graduating from A&T to constantly challenge racism and injustice. He has been elected to several terms to the Soil and Water Conservation Commission.

JESSE LEADS PROTEST. Jesse Jackson returned to Greensboro and his alma mater, A&T, to lead a rally and march against South African apartheid. He was a student leader at A&T during the early 1960s, and was a leader of the Civil Rights protests here in the city. He graduated from A&T in 1964.

ANTI-APARTHEID MARCH. Jesse Jackson led thousands to march after an anti-apartheid rally on the A&T campus.

INTERNATIONAL CIVIL RIGHTS MUSEUM. Purely for business reasons, in 1993, the Woolworth Corporation decided to close several of its local stores. Among the stores to shut down was the store in Greensboro where the historic 1960 sit-ins took place. A small group of Greensboro civic and business leaders, led by Melvin "Skip" Alston and Earl Jones, met and agreed that the site should be preserved so that the lunch counter story could be told to youngsters today and future generations. Today, the historic F.W. Woolworth Building, now known as the International Civil Rights Center and Museum, strives to keep the spirit of the sit-in movement alive. Also, it strives to keep fresh the whole issue about the struggles and successes in this country and others that were inspired by the Greensboro Four. McArthur Davis, above, is the executive director of the museum.

Six
SPORTS
ATHLETIC PROWESS

FREDDIE "CURLY" NEAL. Freddie Neal was an outstanding athlete at Dudley High School in the late 1950s before attending Johnson C. Smith University on a basketball scholarship. He joined the Harlem Globetrotters, and with his signature shaved head, magical shooting, and dribbling captured the imagination of fans worldwide. He also had a knack for making baskets far beyond mid-court. During his career with the Globetrotters he played in more than 6,000 games in 97 countries.

TOM ALSTON. "When I was growing up all I wanted to do was play baseball for money," says Alston. He was the first African-American baseball player to play for the St. Louis Cardinals in the early 1950s. He would never get a penny more than $7,500 a year, which was the starting salary for rookies. He got his early start in baseball playing for the Goshen Red Wings in south Greensboro.

LOU HUDSON. "The best basketball player Dudley has ever produced," was how his coach described his star player in 1962. Lou went on to a four-year basketball career at the University of Minnesota and became a first-round draft choice of the St. Louis/Atlanta Hawks. He played for 13 seasons in the NBA, finishing his career with the L.A. Lakers. He was an NBA All-Star and All-Pro.

MURPHY STREET. Murphy began playing golf at the age of nine. During segregation he played at Nocho Park, which was the only golf course for African Americans. It was a shoddy, rugged course with very sparse greens. In the 1960s he played on what was called the "Chitterling Circuit," traveling to such places as Washington, D.C. and Baltimore. Following desegregation of the golf courses in Greensboro—due to the efforts of the late George Simkins—he began playing all of the local golf courses. In 1968 he became the first African American to win the Gate City Open.

STAHLE VINCENT. An All-American and All-State football quarterback at Dudley High School in the late 1960s, Stahle went on to become the first African American to play quarterback at Rice University. He was drafted by the Pittsburgh Steelers. Stahle was an all-around athlete at Dudley, starring also in basketball and baseball.

AGGIE FOOTBALL. An early A&T College football team poses with its mascot.

PANTHER FOOTBALL. This is an early Dudley High School football team from the 1930s.

ALLSTATE ATHLETICS. Pictured are "Butch" Henry (left) and Charles Sanders, both Dudley High School Allstate football and basketball athletes during the 1960s. Butch Henry attended Wake Forest College on a football scholarship. Charles attended the University of Minnesota before moving on to the NFL and an All-Pro career with the Detroit Lions.

ROBERT "BOB" MCADOO #24. Developing his skills on the basketball courts of Benbow Park in southeast Greensboro, Bob attended Smith High School and became an All-State basketball player. Upon graduation he attended Vincennes Junior College before transferring to the University of North Carolina at Chapel Hill. He attended Carolina for one year before deciding to turn professional. He was drafted by the Buffalo Braves (now the L.A. Clippers). His NBA accomplishments speak for themselves. He was rookie of the year in 1973, and on the All-Rookie team. In addition he was NBA MVP in 1975, a five-time NBA All-star, appeared in two NBA Championships, and was enshrined into the Basketball Hall of Fame. He is now an assistant coach with the Miami Heat.

DUDLEY BASEBALL. The first baseball team poses for a team picture. The team went on to win a state championship during the 1960s. It was coached by Bill Furcron.

AGGIE ALL-PRO. A&T football star Elvin Bethea has happy moments checking his professional football contract with friends. After an All-American career with A&T, playing both the offensive and defensive line, he was drafted in the third round by the NFL's Houston Oilers. He had an All-Pro career with the Oilers before retiring. In 2003 he was voted into the NFL Hall of Fame

AGGIE CHAMPIONSHIP. A&T's basketball team celebrates a conference championship in the 1970s. The team was coached by Warren Reynolds. In the 1980s the team, under Coach Don Corbett, won seven straight championships and advanced to the NCAA playoffs.

COACH CAL IRVIN. Cal Irvin began his coaching career at A&T in 1954 as head basketball coach and assistant football coach. In his 18 years as coach he never suffered a losing season, and 18 of his former players were drafted by professional teams.

CONFERENCE CHAMPS. Pictured is the 1970 Dudley football team, which won the conference championship. The head coach was Jonathan McKee. The team also had won the championship the previous year. Coach McKee states, "Public school integration was just taking a foothold in the community. Thirty-five of the football players from the 1969 team were transferred by redistricting to previously all-white Grimsley High School for the 1970 season. Despite this loss of players we repeated as conference champions in 1970."

CHAMPIONSHIP COACHES. Pictured are the Dudley football coaches. From left to right are William Boyers, head coach Jonathan McKee, and Helburn "Bud" Meadows.

#1 FOOTBALL COACH. Named A&T's 13th head football coach in 1988, Bill Hayes went on to become the all-time most successful coach after 15 seasons. Winning over 100 games at A&T, Hayes became known as a top-notch recruiter, excellent at field coaching and a master motivator. He built a program that was a consistent winner. He produced MEAC Conference champions and post-season winners. Hayes was actively involved in the community and conducted golf tournaments and coaching clinics for high school coaches.

RUTH MORRIS. Ruth Morris was an outstanding A&T track athlete during the 1980s. Coached by Roy "Spaceman" Thompson, she participated in the Seoul Olympics in 1988 in the 200- and 400-meter events. She was a native of St. Thomas, Virgin Islands.

SEEDER PROGRAM. For several years Coach Jonathan McKee at Dudley High School conducted a summer sports program for youth under the auspices of the federal government known as CETA (Comprehensive Employment and Training Act), which was introduced by the Carter administration. Pictured are one of the basketball teams whose talent McKee helped develop through early competition.

THE JACKSONS. Jesse Jackson poses with his two sons Jesse Jr. (left) and Jonathan after an Aggie football game. Jesse Sr. played for the Aggies while a student in the 1960s. His sons both played under Coach Bill Hayes in the 1990s. Jesse Jr. is now a United States Congressman from Illinois.

LAMONT BURNS. A Page High School graduate and star football player, Lamont attended East Carolina University on a football scholarship before being drafted by the New York Jets. He played in the NFL with the Jets, Philadelphia Eagles, and Washington Redskins.

VINCE EVANS. A star quarterback at Smith High School, Vince Evans became the Most Valuable Player in the Rose Bowl while playing quarterback for Southern California. He was drafted by the Chicago Bears of the NFL and played professionally with them until an injury ended his career.

WAYNE ROBINSON. Wayne Robinson is president and CEO of the Center for Champions, Inc., which he founded in 1993. It is an after-school and summer enrichment program. A former chair of the Governor's Council of Physical Fitness and Health, he is also a former NBA Player for the L.A. Lakers and the Detroit Pistons. He starred in basketball at Greensboro Day School. He is pastor of equipping (Christian Education) at Mt Zion Baptist Church. He says, "The young adults of today represent the brightest, the most talented, and most resourceful . . . Older adults who hear the heart cry must strive to interact with this generation . . . otherwise we will lose them."

Seven
LIFE IN THE COMMUNITIES
DISTINGUISHED NEIGHBORHOODS

THE WARNERSVILLE COMMUNITY. The history of the Warnersville community is unique, as it is the oldest organized African-American community in the Greensboro area. In 1968, Yardley Warner, a Philadelphia Quaker, sold 35 acres of land to emancipated blacks who yearned for independence and home ownership. Despite constant changes and marked transitions occurring within the community, Warnersville became a mecca for black churches, economic enterprises, schools and colleges (like Bennett College), and community self-sufficiency. During the period of redevelopment in the 1960s a complete makeover of the community occurred.

EAST MARKET STREET REDEVELOPMENT. An aerial view of the redevelopment area around A&T shows the two-lane Market Street before it was widened to six lanes. Despite protests from several in the African-American community about the widening, the city insisted that it was integral to the major thoroughfare construction planned for Greensboro. It was proposed by Vance Chavis that only the north side of Market be widened to save business structures located on the south side of the street.

AFRICAN-AMERICAN POLICE OFFICERS. Posing are the first African-American police officers hired by the city in the 1940s. Montgomery and Penn (on the left) were the first officers hired. The African-American officers were limited to "walking the beat" on East Market Street. Later they were allowed to foot patrol the Warnersville community and Gorrell Street area. The officers were not allowed in the downtown area to enforce the law. They were later assigned police car #22 to make arrests.

SYLVESTER DAUGHTRY. Sylvester Daughtry became the first African-American police chief in 1987. He had been a career police officer, rising through the ranks to become chief.

FIRST AFRICAN-AMERICAN FIREMAN. On September 5, 1961 the first class of African-American firemen was formed. They went into training for three months. Upon completion of training they

WALDO AND MARGARET FALKENER. Waldo served on the Greensboro city council in the early 1960s when the first African-American firemen were hired and the first fire station was located in the African-American community. The fire station has recently been dedicated in his honor along with the first 28 African-American firefighters. Mrs. Falkener was active in Democratic party politics and women's issues for many years.

were assigned to a new fire station on Gorrell Street, Station #4. This was the home station for the African-American community. They responded to the entire city only during major fires.

RAY FLOWERS. Ray Flowers was a part of the first class of African-American firemen in 1961. In 1993 he was appointed the first African-American fire chief. He retired in 1999 after 37 1/2 years with the fire department.

THE VINES BUILDING. "We were the only ones to help when the soldiers came. They had nowhere to go but hang out on the street. We gave them a place to eat and shower," says Rosa Vines, who along with her husband owned Vines Cleaners. The Vines opened the second floor of their building for soldiers. Their store was located on the first floor. It was called the USO, and provided entertainment and refreshments for the soldiers, who were only in the city for 12 to 24 hours. The soldiers came to Greensboro to get their orders before going overseas.

"SHOTGUN HOUSES." These houses are thought to be located on Gilmer Street near Trinity AME Zion Church. These houses were economical, easy to heat, and were affordable for the community.

WINDSOR CENTER POOL. In the 1930s this Olympic-size pool was built for African Americans in Nocho Park.

"CLICK." Swimmers take a moment to pose for the camera.

THE PALACE THEATER. As one local resident remembered, "We would always say we were going uptown" when we were going to the Palace. This bustling business district on East Market Street was the place for African Americans on the weekend. While growing up kids would receive a quarter for the movies—a dime for the movie, a nickel for popcorn, a nickel for a big soda, and a nickel for candy. The Palace would host road shows on the weekends with dancers and comedians.

101

EAST WHITE OAK YOUTH. The youth of the community enjoy the community center, which was the center of all activities.

EAST WHITE OAK YMCA. The Cones donated this school in the 1920s for their employees living in the White Oak community. It was first used as a school before becoming a community YMCA and then a community center. This building is on the National Register of Historic Places.

Mt. Zion Community. The combined churches of the Mt. Zion community posed for this picture in 1952. They grew up with the city landfill, which is currently planned for closing. They fought environmental racism for over 50 years. The landfill was placed in the community in 1943.

Community Cannery. The Mt. Zion community, located in northeast Greensboro, built a community cannery so that neighbors could come together and share their food and knowledge. This building was also used for a school in the 1940s. (Courtesy of Greensboro Historical Museum.)

L. Richardson Hospital. This hospital for African Americans was opened in 1927 on the corner of Benbow and McConnell Roads. It was the first hospital for African Americans in Greensboro. The Greensboro Negro Hospital Association raised $100,000 to construct it, with the Richardson family contributing $50,000. The Richardsons were founders of Vick Chemical Company. The hospital was moved to a new location in 1966. The original hospital has been restored into affordable residential housing by Project Homestead. (Courtesy of Greensboro Historical Museum.)

Prenatal Clinic. In the 1940s Greensboro saw a high infant mortality rate of almost 28%. L. Richardson Hospital offered women classes on prenatal health to help ensure a safe and healthy infant delivery. (Courtesy of Greensboro Historical Museum.)

CANDY STRIPERS. Many persons from the community volunteered at L. Richardson Hospital. This group of young ladies volunteered as candy stripers during the summer to assist the staff with non-medical needs.

SPIRITUAL RENAISSANCE SINGERS. Dr. Patricia Johnson Trice, Dr. Charlotte Alston, Elvira Green, Dr. Clifford Watkins, Valerie Johnson, and Vivian McCulloch formed a group of 20 singers to preserve and perpetuate the unaccompanied arrangements of African-American spirituals in August 1999. For Trice, the spiritual sung without music is an art, a poetry that speaks to America's heritage, particularly that of black America. The music sung by the group evolved from slave songs into spirituals.

MEMBERSHIP DRIVE. The campaign motto of the Hayes-Taylor YMCA was "Spizzerinktum" which means "go get them" in German. Many people from the community volunteered annually to raise memberships for the Y. Picture above is the executive board meeting during a membership drive.

"Y" YOUTH PROGRAMS. Hayes-Taylor YMCA made an effort to involve the community youth in their programs. There were sleep-ins, movies, haunted houses, and hiking trips. Pictured above is a birthday party for one of the youth members.

BLACK CHILD DEVELOPMENT INSTITUTE OF GREENSBORO. The Black Child Choir, formed in 1984, was famous for the large number of children involved and their great sound. In 1989 they performed for the National Conference on Black Children in Washington, D.C. They also performed at the King Center in Atlanta and for numerous other local and national events. The choir was directed by Jimmy Cheek.

100th Birthday Celebration. The great-granddaughter of Dr. Warmouth Gibbs plays a violin solo in honor of his 100th birthday. Dr. Gibbs served as A&T's fourth president. He is pictured

second from right in the front row.

THE SHINING STARS COMMUNITY CHOIR. The choir was organized in 1976 to provide area youth, between the ages of 5 and 15, an opportunity to use their talents by performing at churches,

banquets, and other social affairs in the community. The choir was organized by Jeanne Lanier-Rudd.

MARGARET TYNES. Jimmy Williams (left), former A&T assistant band director, and Dr. Lewis Dowdy pose with A&T graduate and international opera singer Margaret Tynes. She was on the campus for a performance and is a Greensboro native.

HARRIS-MINTZ DANCE COMPANY. The Harris-Mintz Dance Company began in 1977 as the St. James Modern Dance Ensemble, which was a part of the church's ministry. The dance ensemble was the brainchild of Laverne Harris and Carolyn Mintz. Wanting to reach out and offer dance to young persons in the community, the two ladies formed the Harris-Mintz Dance Company, which performs at many functions in the city. It has traveled to perform for Gov. Jim Hunt and Ebernezer Baptist Church in Atlanta. Above, Harris (left) and Mintz (right) pose with dancers and Dr. Ben Hooks after a performance.

Eight
SOCIAL LIFE
CLUBS AND FESTIVITIES

DELTAS CELEBRATE 50 YEARS. The Beta Mu Sigma chapter of Delta Sigma Theta Sorority gathered in 1992 to celebrate 50 years of service to the Greensboro community. The chapter was chartered in 1942 with Elizabeth Gibbs serving as the first chapter president. Deltas have been very active in the social life of Greensboro, sponsoring the Jabberwock, providing scholarships, promoting voter registration, and sponsoring health fairs. Today the chapter boasts over 200 active members.

GREENSBORO MEN'S CLUB. As it nears 75 years of service, the Greensboro Men's Club is an organization of 36 men whose purpose remains to promote genuine fellowship among its members and the maintenance of high intellectual social and civic standards. Individual club

members and the organization are sought out for civic projects in the city. Thomas J. Scott serves as its current president. Pictured above are members of the club in the 1970s.

SATURDAY EVENING JAM SESSIONS. During 1947 and 1948 musicians would gather on Saturday evenings in A&T's Harrison Auditorium to entertain the students. Pictured above from left to right are Carl Foster, Lou Donaldson, and Billy Tolles.

EVENING SOCIAL. Ann Davis, wife of A&T Physician Dr. F.E. Davis, hosts a picnic at her home.

"EMCEES." Memberships in many professional social clubs were limited, which led David Morehead, executive director of Hayes-Taylor YMCA, to form an organization of professional businessmen named the "Emcees." It was a social organization but also provided community service often by providing assistance to students desiring to go to college.

EMCEE SWEETHEARTS. The Emcees often hosted affairs to involve the wives and sweethearts of members. Above Emcee sweethearts are hosted at a Valentine party at the Y.

117

MID-CENTURY CLUB. Members of this social club were aptly named because all members were in their fifties. The club was limited to 14 members and was hosted at club members' homes for an evening of social activity.

LINKS INDUCTION. Newly inducted members of the Links social club pose for the camera. They are, from left to right, Effie Miller, Dorinda Trader, Alma Stokes, Millie McFadden, Gwen Blount, and Shirley Frye.

DEBUTANTE BALL. The first debutante ball, sponsored by Beta Nu Zeta chapter of Zeta Phi Beta Sorority, was held on April 26, 1952 at Windsor Center. Nineteen debutantes were presented, and Florine Irwin Stafford was crowned debutante queen.

MORTGAGE BURNING. The sorority house for Beta Nu Chapter was purchased in 1990. It is located at 1015 Homeland Avenue. In the summer of 2002 the final mortgage payment was made. The mortgage burning celebration was held on November 2, 2002.

THE MIGHTY MAJORS. The majors were formed in 1964 at A&T College to play as backup for a talent show. They were made up of A&T students and mostly music majors. Over the years the band has opened for major shows across the country and has backed up R&B singers Gene Chandler, Jerry Butler, and Aretha Franklin. The Mighty Majors have produced 10 recordings.

DANNY RICHMOND. Danny started his music career at an early age playing the saxophone with the Rhythm Kids. He later moved to New York, switching to the drums and becoming one of the premier drummers in the country. He is pictured above with Walter Carlson, former band director at A&T.

COVACUS. The Covacus Band was founded in 1980 by James "Coffee" Yourse and Anthony, Lawrence, and Reginald Graves as a backup band for talent shows at the Trevi Fountain Club. It played for many social events in Greensboro in addition to traveling the east coast to major colleges and universities.

BARBARA WEATHERS. This talented Greensboro singer started her career with Covacus, showcasing her extraordinary talent. She later joined the popular R&B group Atlantic Starr. She became the lead singer in popular hits such as "Secret Lovers" and "If Your Heart Isn't In It." In the late 1980s she left the group for a solo career.

The Versatile Gents. This group, organized in 1967 as the "African Americans," performed at a talent show at Gillespie Park School. Soon after Virginia Massey, a senior music major at A&T, joined the group and the named was changed to "Gin and the Gents." After one year Massey left the group and the name was changed to the "Versatile Gents." The group went on to record several hits and made the Top 10 Billboard.

AKA REGIONAL CONFERENCE. The Beta Iota Omega chapter hosted the 1960 regional conference at the Pearson Street YWCA. Because of segregation, hotels and other banquet facilities were not available to African Americans. Out-of-town guests stayed in homes of friends and relatives of the hosting chapter. Above, Dr. Lucille Piggot (president) speaks to the group.

AKA HOSPITAL ROOM. The AKA Sorority sponsored a room at the L. Richardson Hospital, to which it donated equipment and furnishings. Above, Dr. James Smith, the hospital administrator, receives medical equipment from some members of the sorority.

COSMOS. The Cosmos Club was opened in 1970 by Richard Bowling. It was the social gathering spot for young adults, with the Friday evening "happy hour" attracting large crowds. In 1975, a restaurant was added allowing the club to host banquets, wedding receptions, and other social affairs. The name was later changed to Trevi Fountain. Pictured above is Richard Bowling, right, with some members of his staff.

JONES-MORRISEY BAND. This rare photograph, thought to be from the 1920s or 1930s, shows a group of African-American musicians who no doubt played with a "big band sound." The photograph is courtesy of M.A. Scarlette.

DRIFTERS. The Greensboro Chapter of Drifters, Inc. was incorporated in 1972 by Yvonne Johnson. The Drifters is a group of dynamic women whose interests include social, civic, and educational projects.

LAS AMIGAS, INC. This service organization's local chapter was organized in 1967 by Lola McAdoo with eight charter members. It has been committed to volunteering, contributing to, and working with youth and families in the Greensboro communities. Over $100,000 in scholarships have been provided to young people in the community. The primary fundraiser for the chapter has been the Vals Purez Hovenez Ball (An Evening For Young Ladies).

KARAMU. Karamu is an African-American arts festival presented during Black History Month. This event is high energy, filled with cuisine, fashions, various musical performers, storytelling, and arts and crafts. Karamu provides interactive arts for youth while promoting self-awareness and a deep appreciation of contributions made in the arts media by African Americans.

"THE BLUES." Melva Houston, local blues, jazz, and gospel singer, performs at Karamu.

"Art." A young child creates art as part of the Karamu Festival.

African Cuisine. African food is sampled by the quests of Karamu.

CAL APPRECIATION. Former members of Cal Irvin's basketball team gathered for a social gathering to show their appreciation for his mentoring and leadership. Al Attles, former professional player, and "Big House" Gaines, former rival coach at Winston-Salem State, were among those in attendance.

THE EVERACHIEVING CLUB. Retired teachers gather monthly at Hayes-Taylor YMCA to socialize and enjoy fellowship.